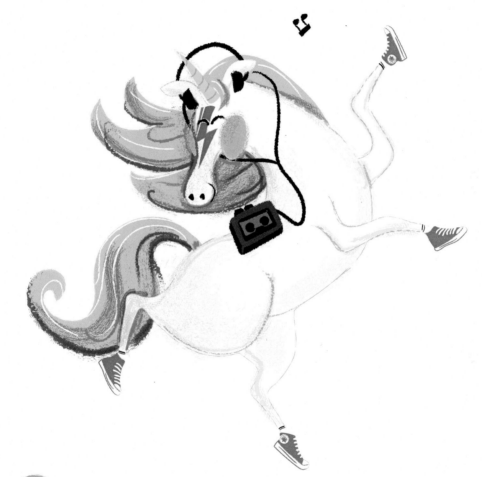

Vampirocorn

Geofrey Scott Redd

Karen Warner

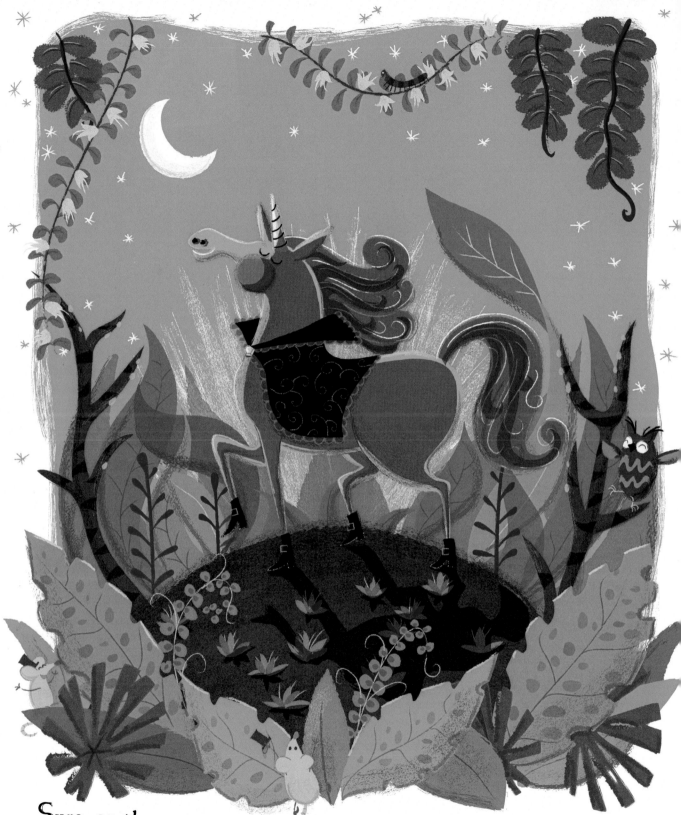

Sure, on the surface, he looks like a majestic horse of JOY,
But things aren't exactly what they seem for this Unicorn named LEROY.

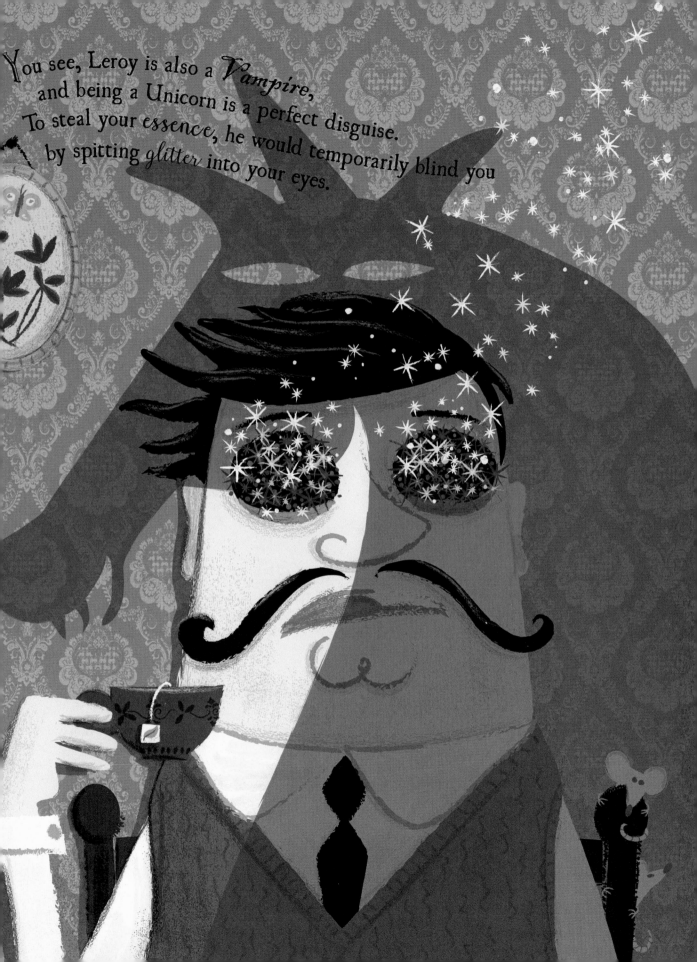

You see, Leroy is also a *Vampire*,
and being a Unicorn is a perfect disguise.
To steal your *essence*, he would temporarily blind you
by spitting *glitter* into your eyes.

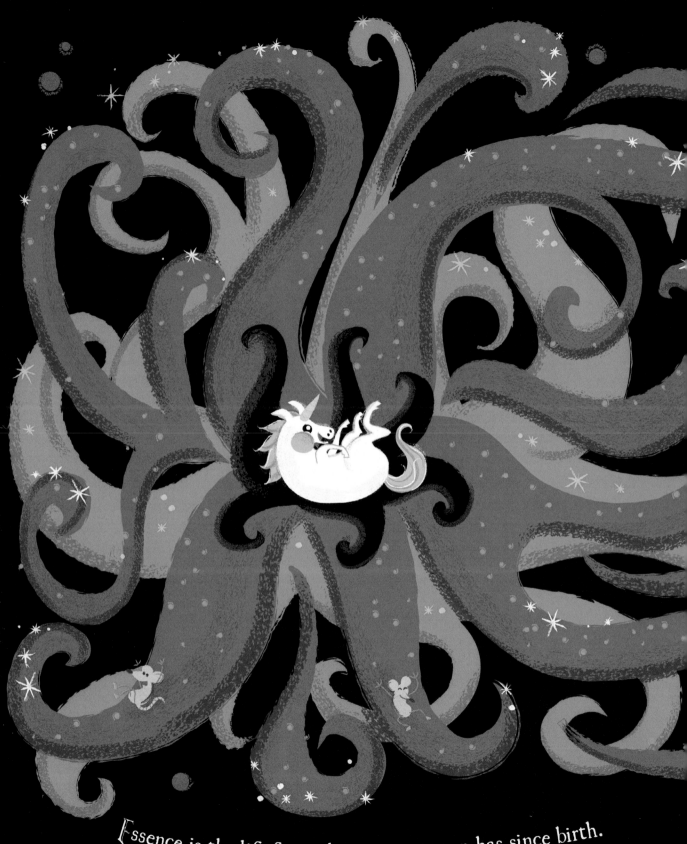

Essence is the life force that every person has since birth.
It's the thing that's deep inside of you that gives YOU all your worth!

Vampires feed off essence; it's how they live so long,
And they STEAL it from people, even though they know stealing is wrong.

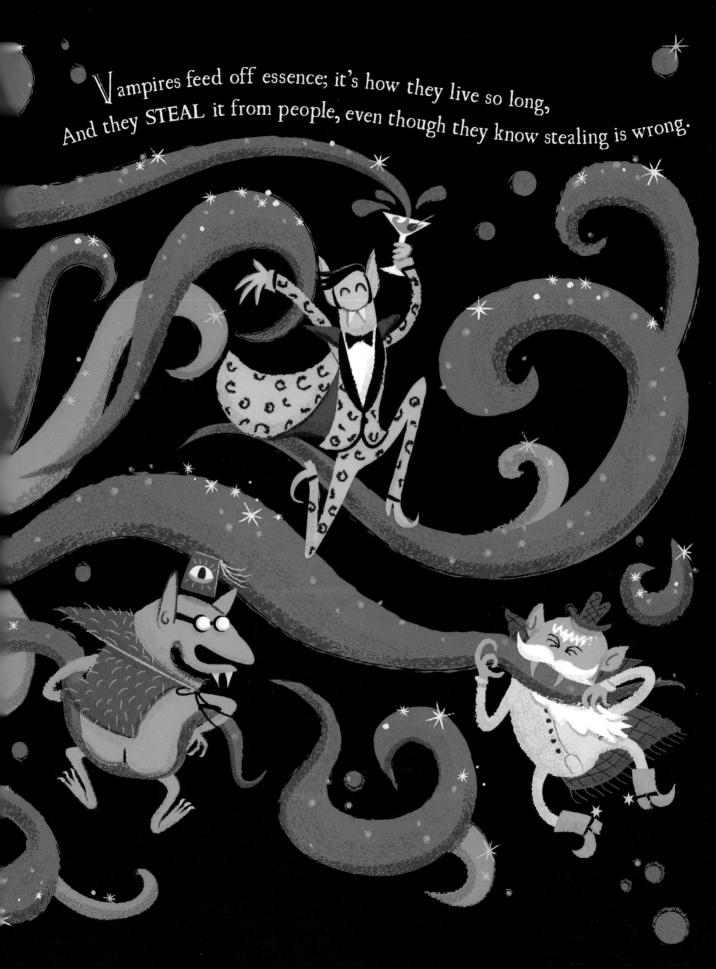

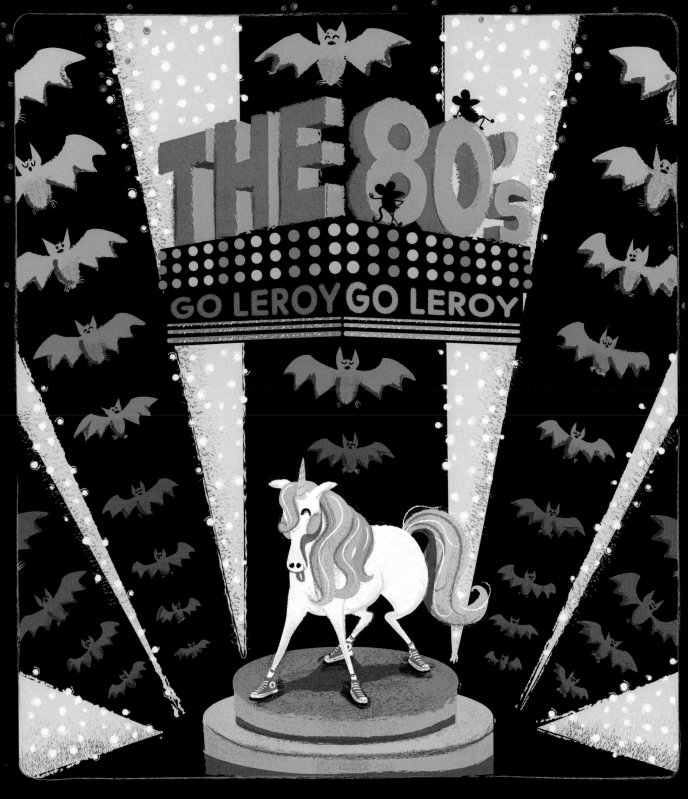

Leroy, of course, never intended to be like *this*.
It was some time in the mid **80's** that his life as a *Vampirecorn* came to exist

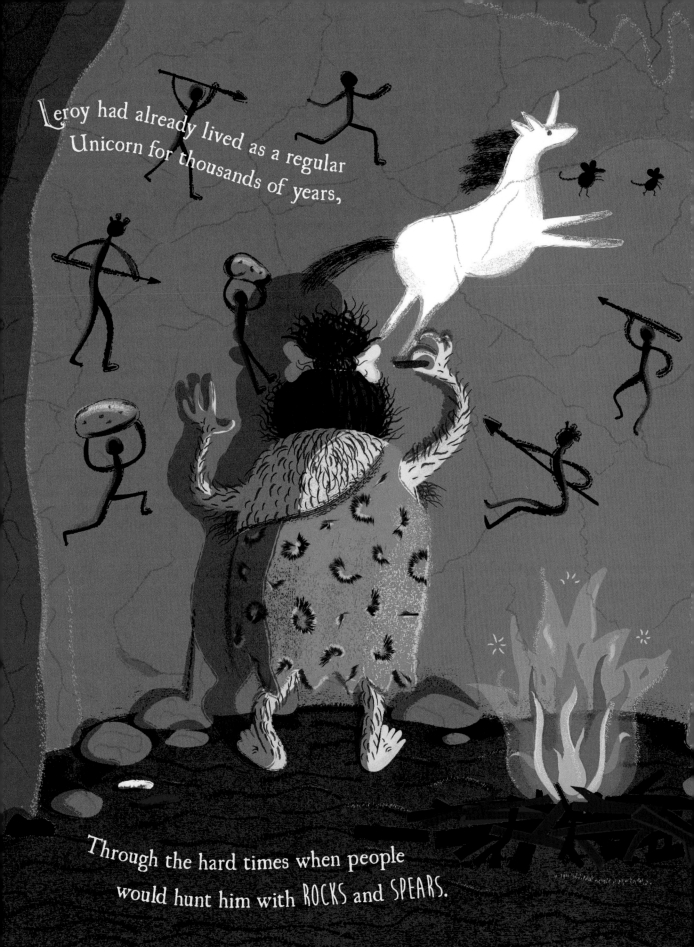

Leroy had already lived as a regular
Unicorn for thousands of years,

Through the hard times when people
would hunt him with ROCKS and SPEARS.

The incident happened while he was walking and listening to **Bowie** in his headset.

Meanwhile, a *vampire* named *Vlad* saw the Unicorn and *wondered* if he'd be a threat.

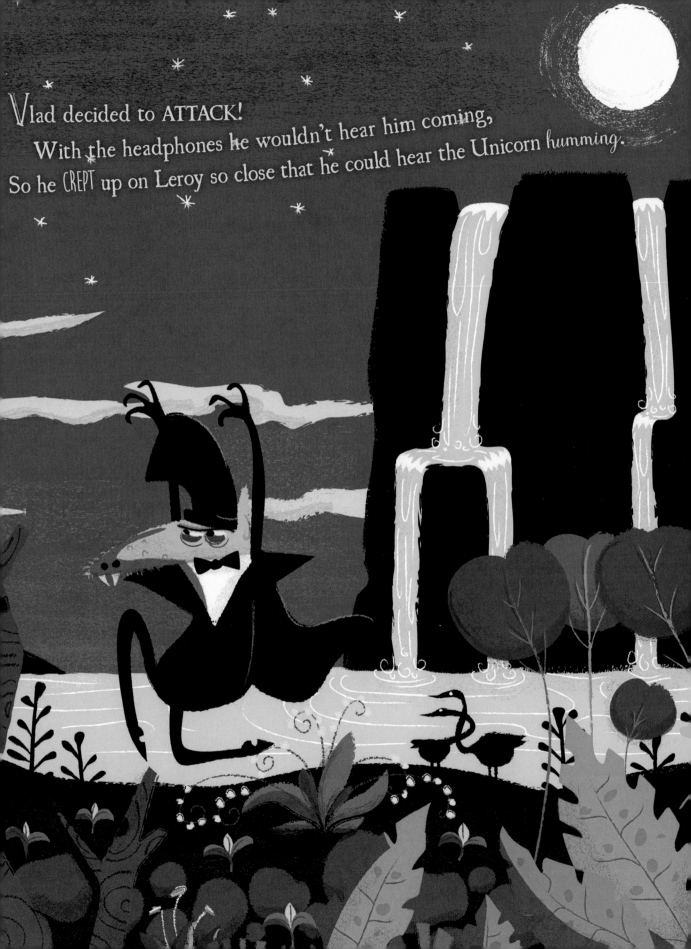

Vlad decided to ATTACK!
 With the headphones he wouldn't hear him coming,
So he CREPT up on Leroy so close that he could hear the Unicorn humming.

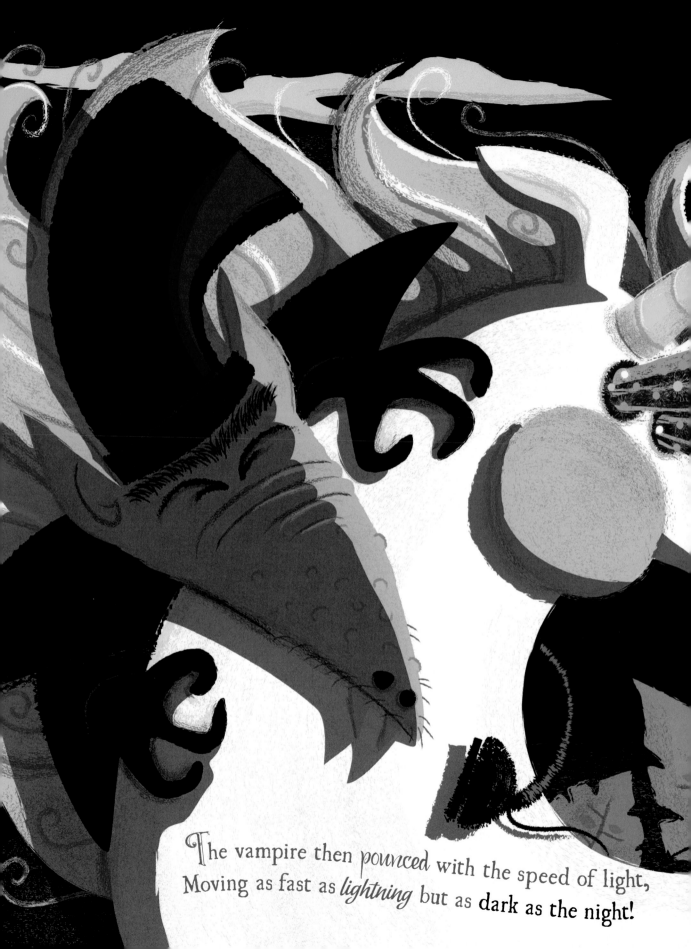

The vampire then *pounced* with the speed of light,
Moving as fast as *lightning* but as dark as the night!

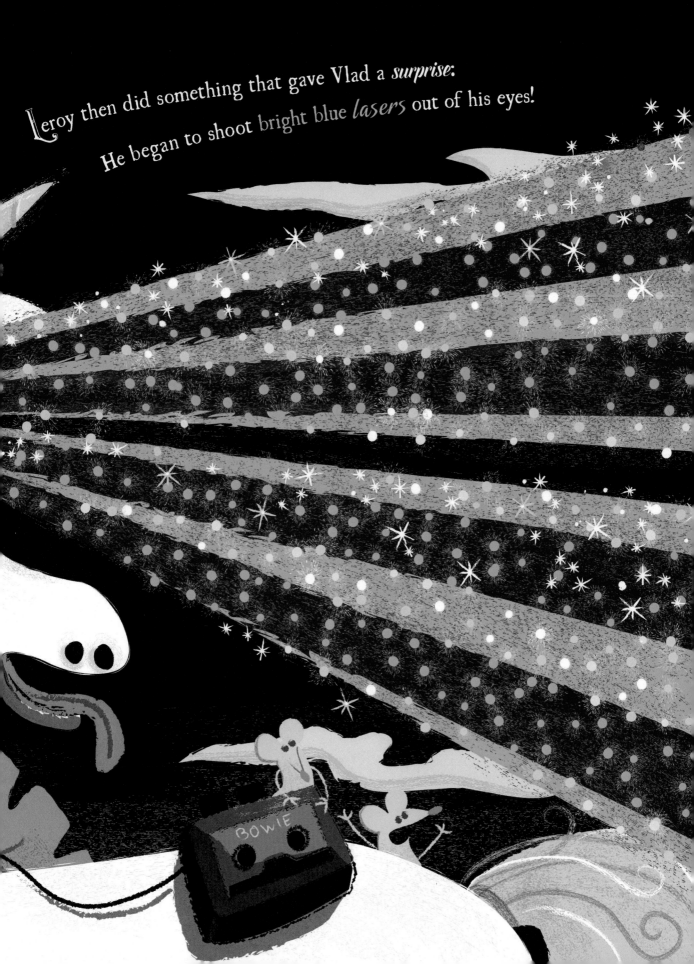

Leroy then did something that gave Vlad a *surprise*:

He began to shoot bright blue *lasers* out of his eyes!

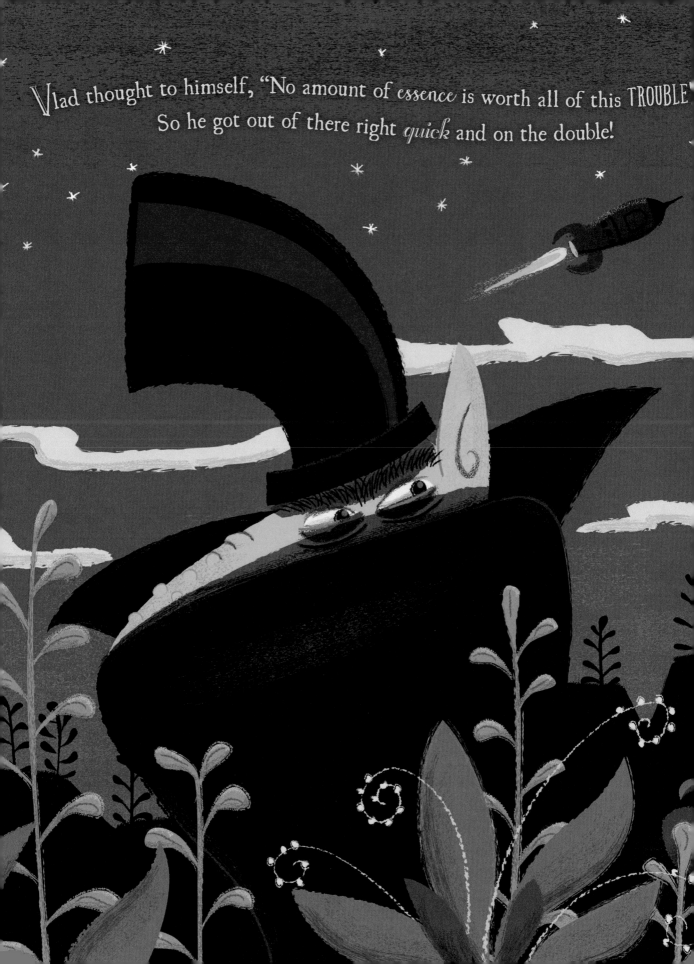

Vlad thought to himself, "No amount of *essence* is worth all of this TROUBLE"
So he got out of there right *quick* and on the double!

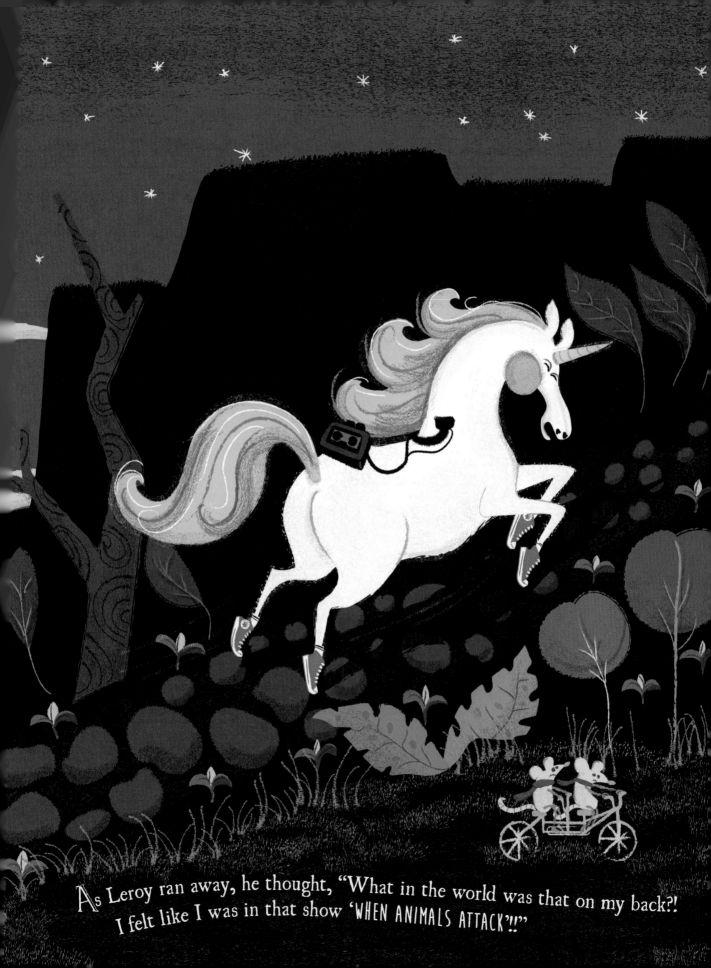

As Leroy ran away, he thought, "What in the world was that on my back?! I felt like I was in that show 'WHEN ANIMALS ATTACK'!!"

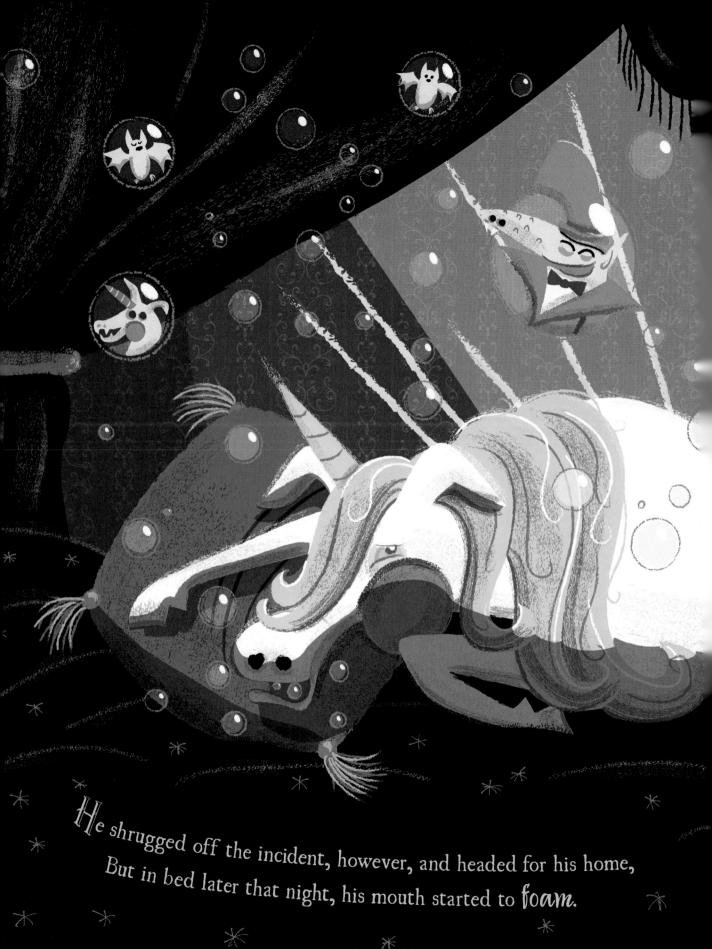

He shrugged off the incident, however, and headed for his home,
But in bed later that night, his mouth started to *foam*.

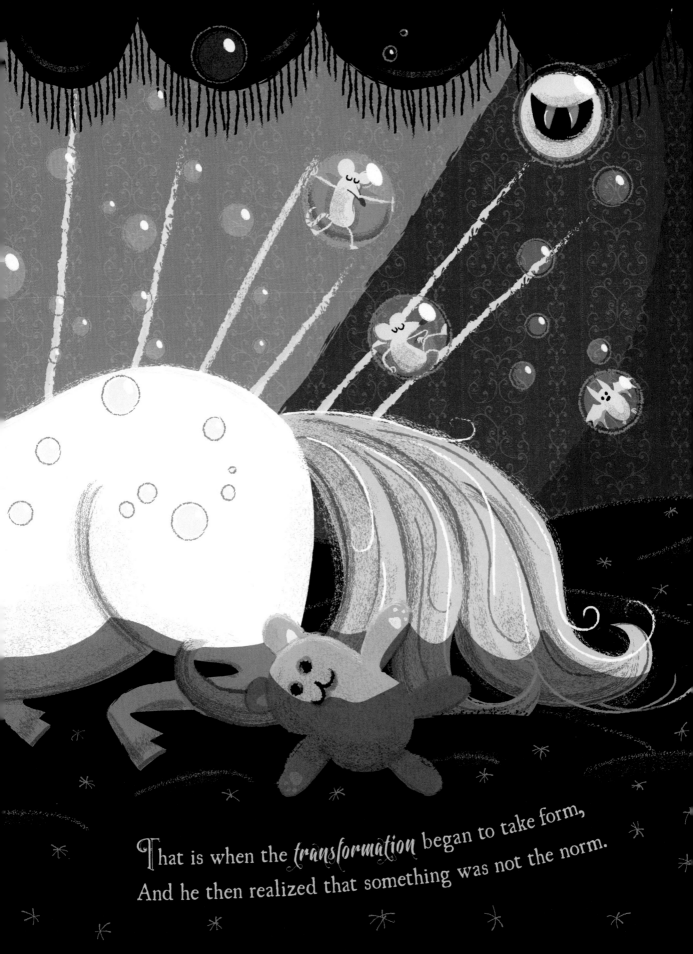

That is when the *transformation* began to take form,
And he then realized that something was not the norm.

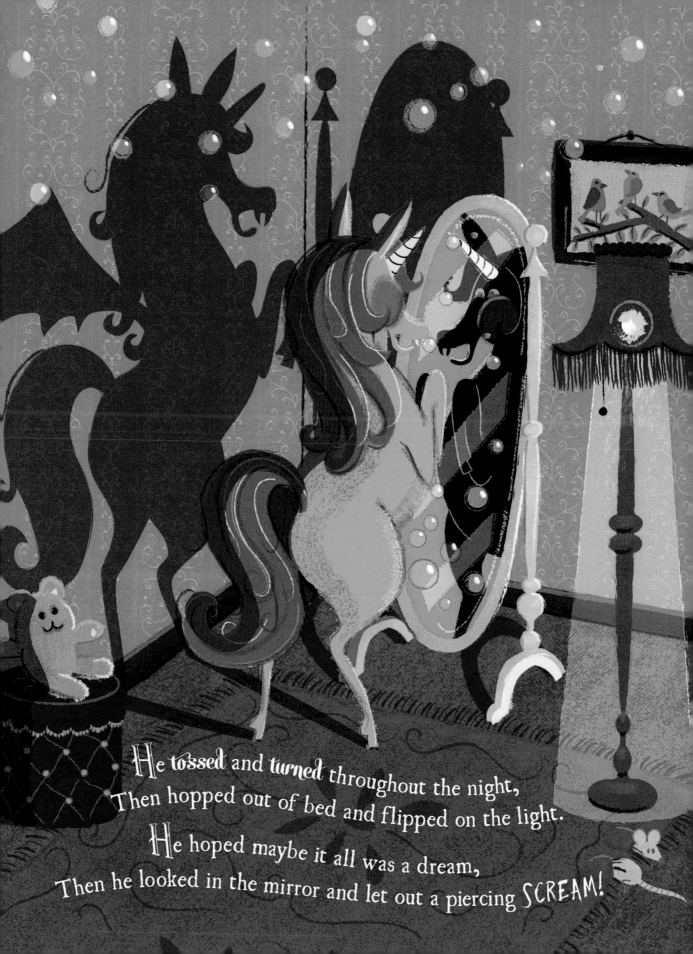

He tossed and turned throughout the night,
Then hopped out of bed and flipped on the light.
He hoped maybe it all was a dream,
Then he looked in the mirror and let out a piercing SCREAM!

Instead of solid gold, he now had a **Black** and gold spiral horn.

He had never seen a SCARIER-looking Unicorn!

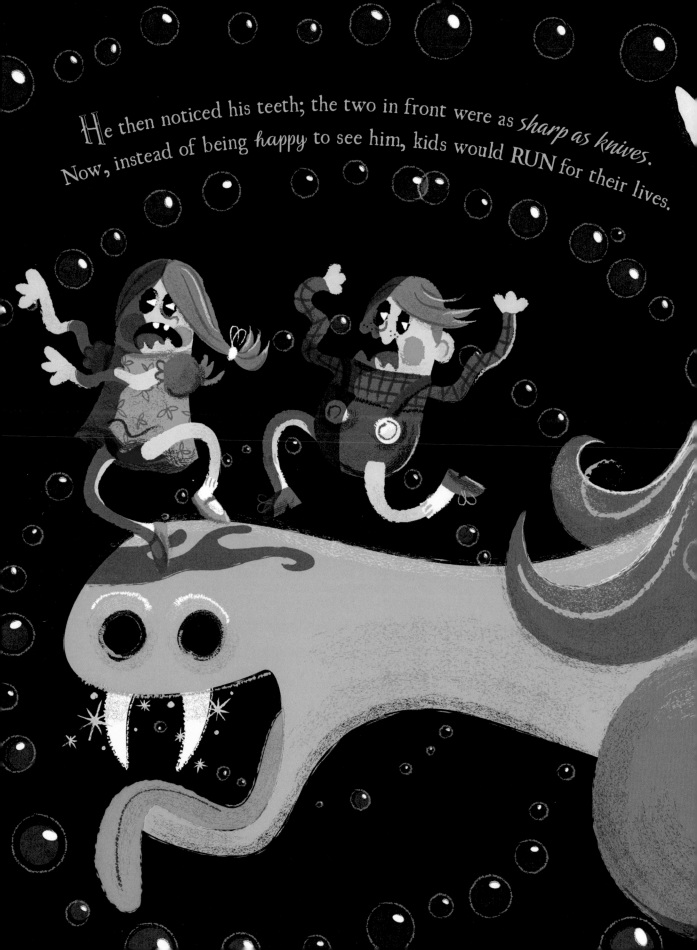

He then noticed his teeth; the two in front were as *sharp as knives*.
Now, instead of being *happy* to see him, kids would RUN for their lives.

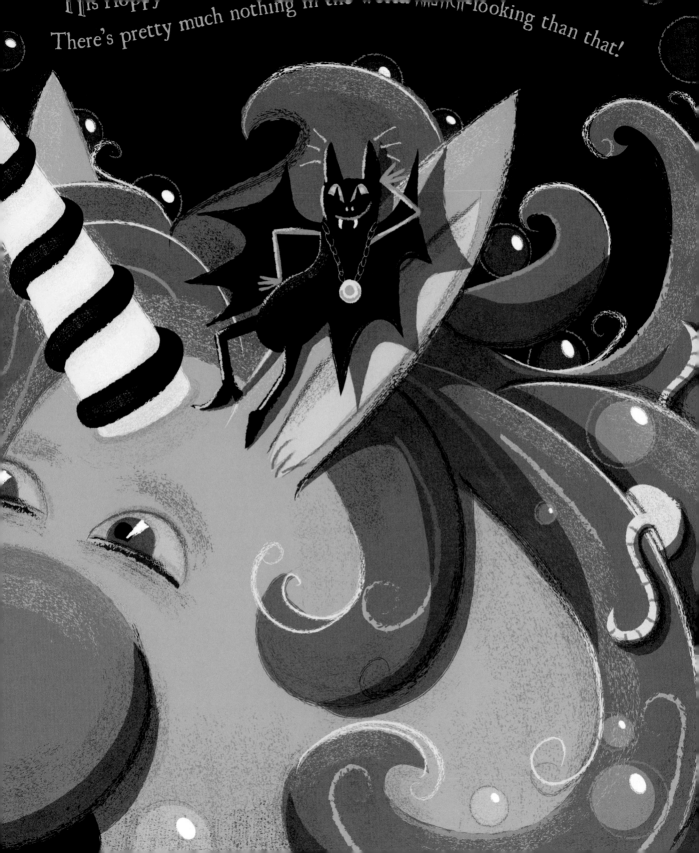

...rong, this newfound thirst for essence was the worst.
He realized these were all *vampire* symptoms,
and he knew then that he had been CURSED.

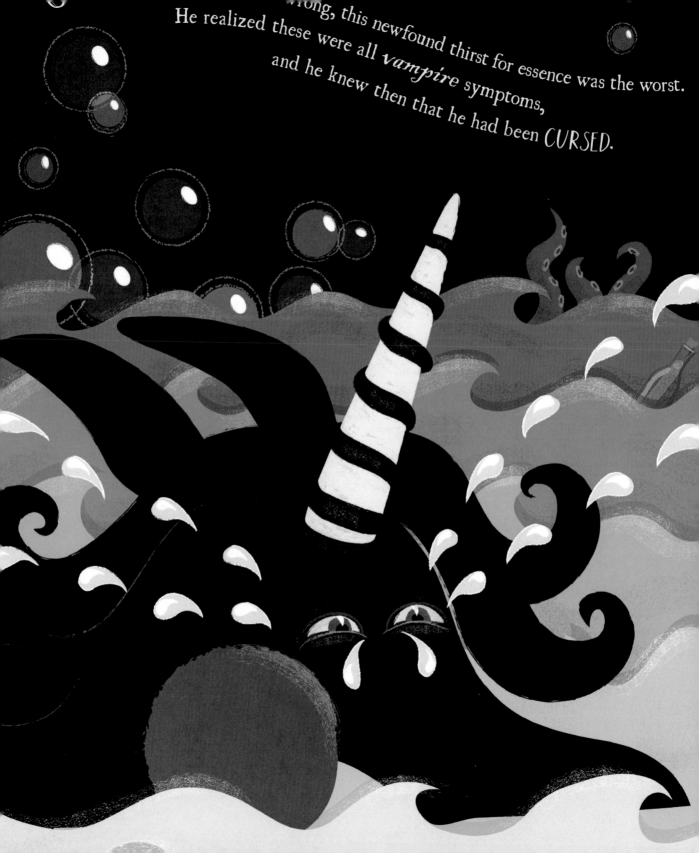

Leroy wept because he knew that he was now **doomed** to be a creature of the night.
And feel the PAIN of his skin burning in the sunlight.

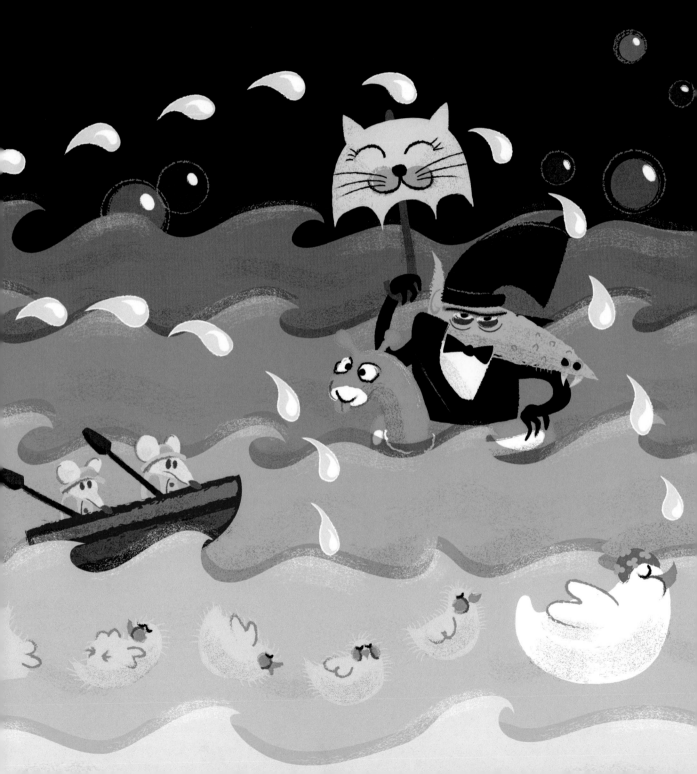

He decided to get it over with and expose his body to the sun outside,

But, because his fur *shielded* his skin from the light, he would not have to hide!

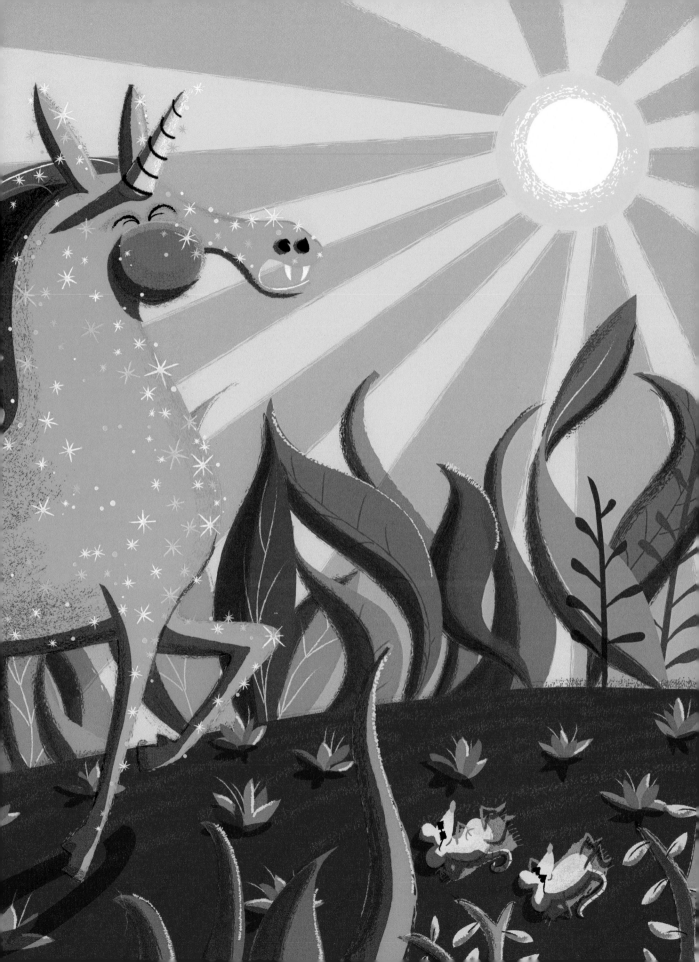

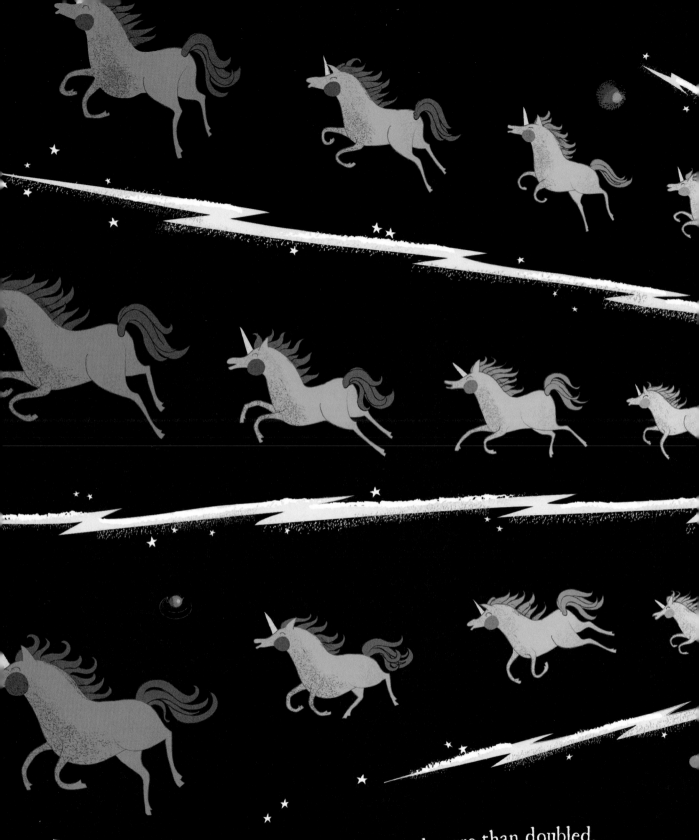

He also discovered that his *magical powers* had more than doubled,
And he started to think that there was no reason for him to feel so *troubled*.

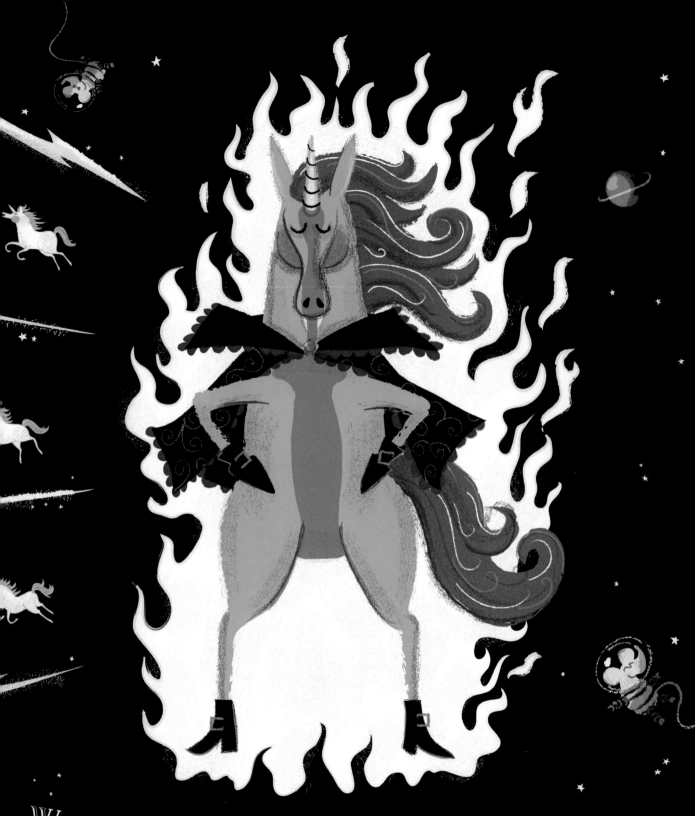

What would he do now? He was the first, and so far, *only* of his kind,
With the strength of both Unicorn and *Vampire* combined!

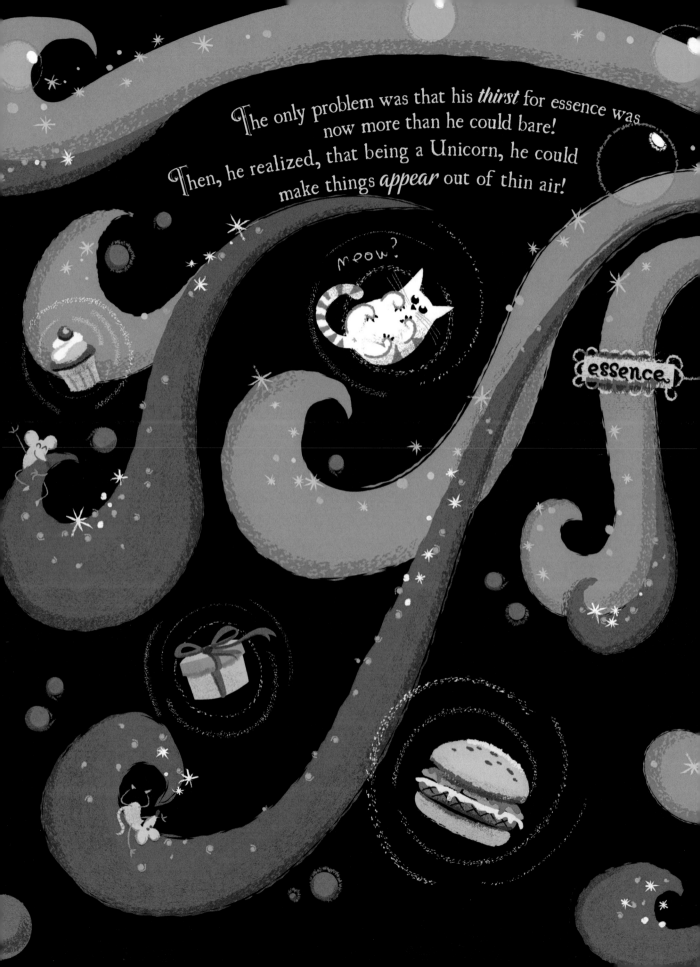

The only problem was that his *thirst* for essence was now more than he could bare!
Then, he realized, that being a Unicorn, he could make things *appear* out of thin air!

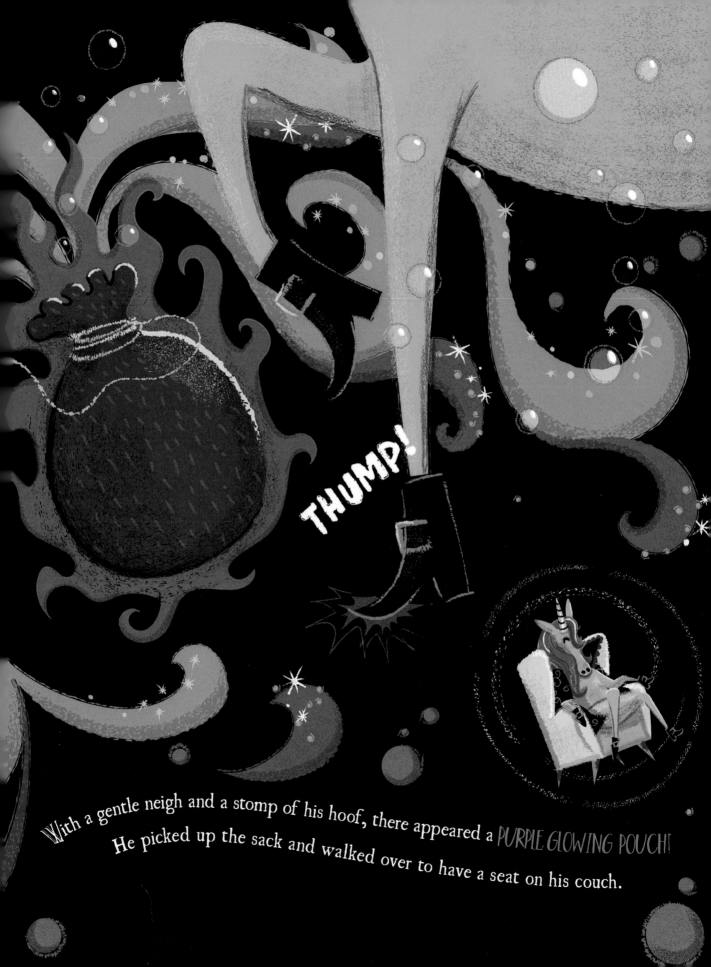

THUMP!

With a gentle neigh and a stomp of his hoof, there appeared a PURPLE GLOWING POUCH!
He picked up the sack and walked over to have a seat on his couch.

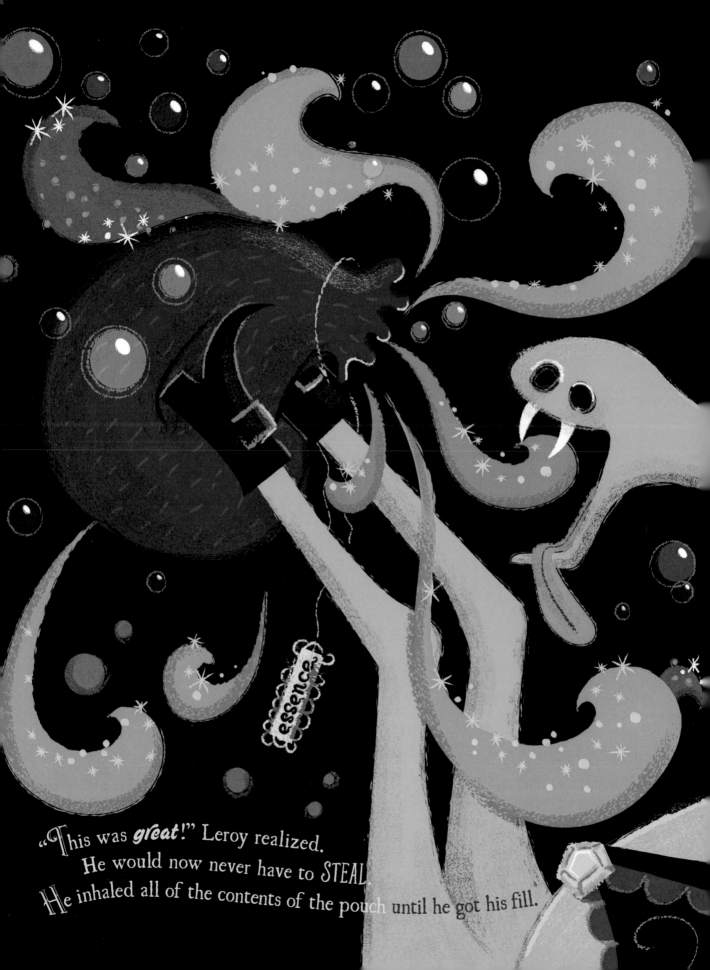

"This was *great!*" Leroy realized.
He would now never have to STEAL.
He inhaled all of the contents of the pouch until he got his fill.

Leroy, feeling **content** and as **happy** as can be,
came up with a great idea to open a shop called P.O.E.

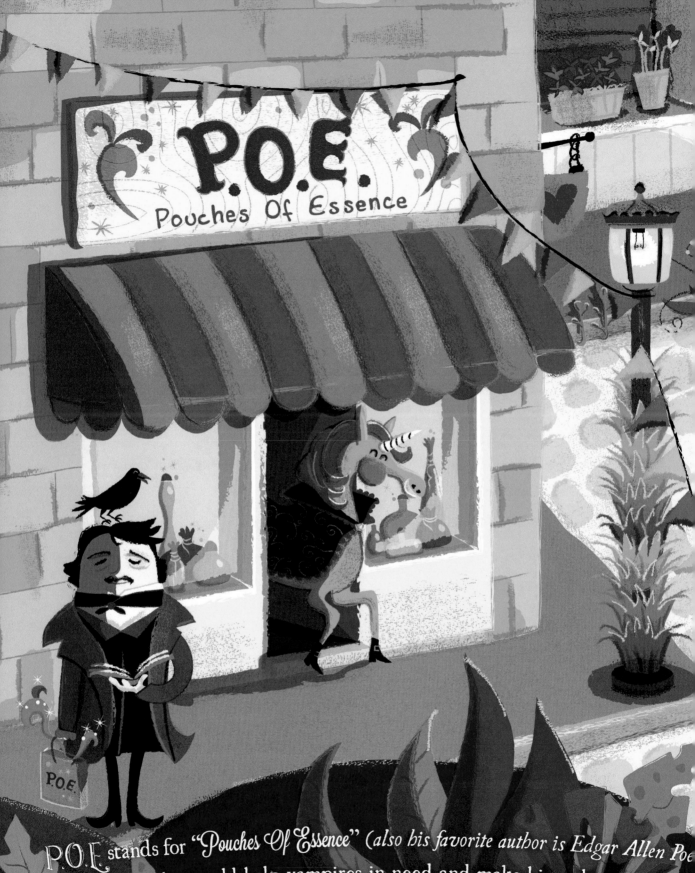

P.O.E. stands for "*Pouches Of Essence*" (also his favorite author is *Edgar Allen Poe*).
He knew this could help vampires in need and make him a lot of dough.

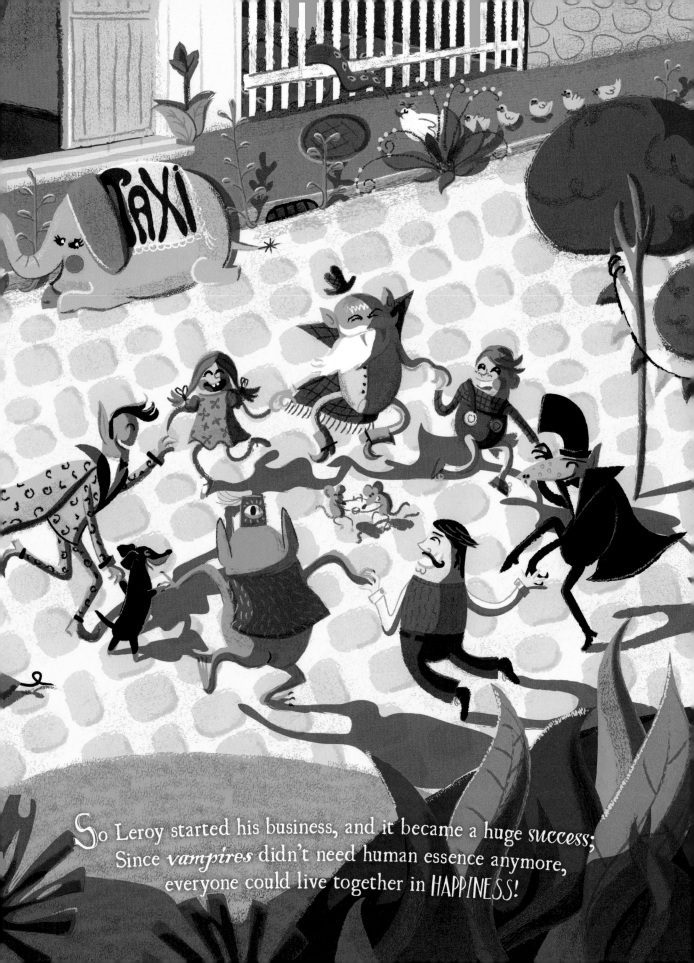

So Leroy started his business, and it became a huge *success*;
Since *vampires* didn't need human essence anymore,
everyone could live together in HAPPINESS!

My name is GEOFREY REDD. I am a graduate of the Art Institute of San Diego with a degree in graphic design. I have been writing poems since childhood and love telling stories. I am also a visual artist and go by the name of Yarns & Noble when creating artwork out of yarn and nails.

WWW.YARNSANDNOBLE.COM

My name is Karen Warner. I am from Spain. I am an illustrator and a graphic designer. I enjoy looking at the weird and fantastic things that are around us everyday. Where I really feel happy, full of color, love and good moods is drawing in my personal world.

www.illustrapow.com

please email vampirocorn@gmail.com for all inquiries

Geofrey wrote **Vampirocorn** as a project for a creative writing class in college. While looking on Instagram for an artist that was perfect to illustrate the tale, he stumbled upon Karen's art. He sent an email across the ocean to Spain to ask Karen if she would be interested in illustrating Leroy's tale. She loved the story, and they decided to work as a team to make this book a reality. Despite the challenges of collaborating across continents, they worked together on illustrations and the story. Geofrey then contacted Alea Ferrier to do the typography and handle the book layout, and thus, Vampirocorn was born. This book took three friends the better part of a year and a ton of imagination to create. We hope you enjoy our work!

Made in the USA
Lexington, KY
17 July 2018